BLUEFIELD
VIRGINIA

IMAGES of America

To: Caroline
From: Monty and Debby Ramella
August 2015

The seal of Bluefield, Virginia, advertises "Virginia's Tallest Town." The unique title was the idea of Bill Osborne, a devoted community leader who won a town-sponsored slogan contest in 1963. The Osborne family came to Graham in 1911, and Bill graduated from Graham High School in 1929. In business, he was associated with the sales department at Chicago House Furnishing Company. He and his family were among the early Graham residents who helped shape the town. (Courtesy of the Greater Bluefield Chamber of Commerce.)

ON THE COVER: The Wartburg Seminary faculty and students gathered for the photographer around 1890. The founder, the Reverend Joseph B. Greever, D.D., is seventh from the left on the back row. Dr. Greever had a noteworthy ministerial and teaching career. He was responsible for the establishment of numerous Lutheran congregations and schools. During this time, he was also engaged in the real estate business with his brother-in-law, William L. Spracher, in Bluefield, Virginia. He was also the vice president of Tazewell County's first bank, the Bank of Graham, when it opened in 1890. Wounded at the Battle of Seven Pines, Dr. Greever was the last surviving Confederate soldier from more than 150 original Burke's Garden volunteers. (Courtesy of John Spracher.)

IMAGES
of America

BLUEFIELD
VIRGINIA

Louise B. Leslie and
Dr. Terry W. Mullins

ARCADIA
PUBLISHING

Copyright © 2009 by Louise B. Leslie and Dr. Terry W. Mullins
ISBN 978-0-7385-6796-9

Published by Arcadia Publishing
Charleston, South Carolina

Printed in the United States of America

Library of Congress Control Number: 2009923439

For all general information contact Arcadia Publishing at:
Telephone 843-853-2070
Fax 843-853-0044
E-mail sales@arcadiapublishing.com
For customer service and orders:
Toll-Free 1-888-313-2665

Visit us on the Internet at www.arcadiapublishing.com

William Parham Dudley (1797–1860), the first of that family name to settle in Tazewell County, had a farm close to the Falls Mills dam. Only a few years before his birth, his father and grandfather fought in the American Revolution. This picture is a tintype, an old method of photography no longer used. (Courtesy of the Dudley family.)

Contents

Acknowledgments		6
Introduction		7
1.	People of Graham/Bluefield	9
2.	On the Home Front	41
3.	Virginia's Tallest Town	53
4.	Faith and Learning	81
5.	Blue Fields of Dreams	105

ACKNOWLEDGMENTS

The genuine interest of the people of Bluefield, Virginia, has made this book of images possible. When the Images of America project became known, the pictures were contributed in great numbers. In fact, we had to delete some of the photographs because of space requirements. We sincerely thank all of those people who donated pictures, others who provided information, and everyone who expressed interest in the story of Bluefield, a very special place.

We hope this list of contributors is complete. We apologize if any name has been omitted by mistake. Special thanks go to the Reverend Dr. Don Scott and Peg Scott, Stephanie Rose Musick, Joe Newton, archives of the Lutheran Church in Virginia, John Spracher, Eva Saunders, Dr. James B. McNeer, Lori Yost Moss, Ellen C. Miller, Gary Neal and Bluefield Monument Company, Graham Floral and Teddy Gearheart, officials at the town hall, Donald Harris, Graham Middle School and Karen Woody and Marcia Muncey, Joann Harman, Gail Harman Williams, Pansy Neal, Lisa's Barber Shop, Margaret Elam, Robert Perry, Greater Bluefield Chamber of Commerce, Dr. Stuart McGehee and the Craft Memorial Library, Eastern Regional Coal Archives, the Dudley family, Venture Printing Company, and David Moore.

Important contributions were also made by Margaret Davis Ratcliff, H. B. Frazier, Graham High School, Graham Historical Society, Anthony Stephens, Grubb Photo, Norfolk and Western Historical Photograph College at Virginia Tech, Ruth Brooks Lampert, Lillian Lovelace Brooks Holt, Doug Marrs, Louise McKinney, Tazewell County Historical Society, John Oblinger, Bill Archer, Norma Davis, Kevin Dudley, Bill Dudley, Jim Dudley, Virginia Peery Raley, Debra Waugh, Graham Cracker annual, Drew Marrs, Yiu Fung "Marco" Leung, Tammy Williams, Rusty Fife, Nancy Trenton, Joyce Buchanan, Deloros Denardo Pritchett, Ervin Rich, and the Workman family.

It is easy to imagine a happy occasion at Graham when members of the Painter, Walker, Douthat, Witten, and Neal families posed for this picture in 1916–1917. They are named by Margaret Douthat Elam (starting with the back row but not necessarily in order). George Painter, Tyler Witten, Ida Witten, Francis Neal, Will Painter, C. P. (Perk) Painter (holding Louise Painter Gearhart), Margaret E. Moore Painter, Gladys Walker, Kate Painter, Lillian Brown, Mary Charles, Mary Davis Painter (holding Mary Painter Douthat), Ruth Brown, Roy Witten, Katherine Painter, and Elizabeth Neal Hickam. (Courtesy of Margaret Elam.)

INTRODUCTION

There is a certain charm in the Virginia town of Bluefield, which stems from the combination of a proud heritage and a progressive outlook. Border towns often acquire a strong independence and a sense of loyalty to home and hearth. Bluefield, Virginia, embraces these characteristics as it shares corporation lines and name with its sister West Virginia city. The unique 1924 "marriage" of the two Bluefields is explained in this book. The new name, describing the blue fields of chicory, followed three other descriptive titles for the town.

First, it was Pin Hook. Pin hooking is an old Southern term used for short-term buying and selling of livestock. Perhaps this practice among the early farmers in their fertile lands along the Bluestone River gave the community its first name.

The second name was Harman. There have been families of this name since the early settlements on the Bluestone. But it is believed the town name was in honor of Col. E. H. Harman, a well-known settler who served as the head of his Civil War regiment and was killed at the battle of Cloyd's Mountain.

The third town name of Graham is still used sometimes when referring to the modern corporation. Under this name, the railroad was built to haul the wealth that poured out of the nearby coalfields. Col. Thomas Graham came from Philadelphia to survey for the railroad and acquired tracts of land close to the junction of the Flat Top and Clinch Valley rail lines. Historic accounts record that Colonel Graham laid out the streets for the embryo town, which was called Graham in his honor.

The location of the early towns, and the present Bluefield, Virginia, combine the scenic views of East River Mountain and the lowlands along the waters of Bluestone. Colonel Graham may have been a visionary, as well as a businessman, to establish a town in the midst of such natural beauty. Soon the people came, built homes, and declared in the mid-1800s that this was a good place to settle and raise families. Their decision has never been questioned by their descendants.

Modern statistics for the town of Bluefield tell the facts about "Virginia's Tallest Town." The elevation is 2,389 feet, and the population is 5,030 (2004). Towering high above Bluefield is East River Mountain at approximately 3,700 feet. The town has a total land area of 7.6 miles, which makes it the largest of the five incorporated towns in Tazewell County. The location along the Bluestone River adds to its scenic value and to its industrial growth through the years.

Many descendants of the early settlers are featured in this pictorial book of the Images of America series. The pictures have been contributed by local residents and others who have moved away but still remember their roots. The collection is far from complete, but we have included a cross section of early families, homes, sports, and community events that will tell the story of a special time and place. Some of the contributed photographs have been omitted because of space and deadline requirements. We appreciate the interest and the generosity of the hundreds of area residents who have helped in various ways. It is a community effort, which, we hope, will combine enjoyment with preservation of many of the valuable images of Bluefield, Virginia's heritage.

Margaret Moore Painter and Cary Painter were at their home in December 1955, perhaps a few days before a Christmas celebration for their extended family. An early family member, James Bill Painter, served in the Civil War. His wife, Mary Jane Davis, was a native of Rural Retreat. Some ancestors in the Painter family lived close to Dial Rock. (Courtesy of Margaret Elam.)

C. P. Painter ("Perk") was treasurer of the Bluefield, Virginia, municipality from 1928 to 1960. In the 32 years of outstanding service, he was recognized throughout Virginia as an exemplary public servant. Some of the earlier town treasurers were J. W. Hicks, J. E. Morton, S. M. Graham, R. H. Palmer, C. T. Benbow, K. C. Patty, W. B. Dunn, Laura F. Davenport, Margaret Davis, and Clyde Bowling. C. P. Painter was also a member of the town council at one time. The first mayor of Graham was a Confederate army officer, Capt. John L. Linkous. He was elected in 1884. (Courtesy of Margaret Elam.)

One

PEOPLE OF GRAHAM/BLUEFIELD

The Graham Railroad Station, and the train traffic from the coalfields, was a significant part of the early growth of the town when it was first called Pin Hook and then Harman in honor of Col. Edwin Houston Harman, who was killed at the head of his regiment at the Civil War battle of Cloyd's Mountain in May 1864. The distinguished gentlemen standing in front of the train station are unidentified, but it is easy to recognize they were community leaders who believed in the importance of rail transportation. (Courtesy of Graham Historical Society.)

Cary P. Painter and Margaret E. Moore were married in September 1910. This is their official wedding photograph. The bride was a native of North Tazewell. C. P. Painter ("Perk") holds the record as the longest-serving public official in Bluefield, serving 32 years as town treasurer. (Courtesy of Margaret Elam.)

Three daughters in the Painter family when they lived on Greever Avenue included, from left to right, Mary, Ruth, and Louise. (Courtesy of Margaret Elam.)

Richard Peery was a well-known watchmaker and repairman in Bluefield, Virginia. This picture was taken in 1924. His father was Dewey Peery, the owner of Peery Tile Company. He was known for installing tiles in local hotels and theaters. (Courtesy of Virginia Peery Raley.)

The 60th wedding anniversary celebration for Margaret and Cary Painter was celebrated at their home. Included with the couple are the following family members, in no particular order: Margaret P. Douthat, Ruth P. Brown, Louise P. Gearhart, Hank Gearhart, Bob Douthat, and Grover Brown. (Courtesy of Margaret Elam.)

A visit to Grandma Mary Jane Painter was a treat, although grandson Roy Witten (seated in front) looks a little uncomfortable in the midst of the celebration. The other grandchildren are (in no particular order) Kathryn Painter Bowen, Mary P. Douthat, Ruth P. Brown, Gladys Painter Walker (holding Louise P. Gearhart), and Elizabeth Neel Hickman. (Courtesy of Margaret Elam.)

These cousins stopped for a moment in between play for a quick picture. They are, from left to right, Bobbie Douthat Bellamy (holding Guy Brown), Peg Gearhart DeGray, Richard Brown, and Jim Douthat. (Courtesy of Margaret Elam.)

This distinguished group of the early 1900s has family names easily recognizable in later years because of their accomplishments. They are (first and second rows, not necessarily in order) Cary P. Painter, unidentified, George Painter, Frances P. Neel, Mary Jane Davis Painter, and Lillian Brown (baby in front); (third row, from left to right) unidentified, William I. Painter, Ida Painter Witten, and James Bell Painter. (Courtesy of Margaret Elam.)

13

These happy twins, Lori (left) and Amy Yost, are the daughters of Betty and Ted Yost of Bluefield, Virginia. They were pictured in the spring of 1968. They are granddaughters of Bill and Pansy Neal. The Yost and Neal families have long been a prominent part of the Graham/Bluefield community. Ted Yost was associated with the Flat Top Bank for 40 years, and the early Neal family was instrumental in the establishment of the Bluestone Bedding Company. (Courtesy of Pansy Neal.)

Four generations posed in 1959 at the Virginia Avenue home of Pansy Neal. They are, from left to right, Minnie Belcher, Pansy Neal, Betty Neal Yost, and Pam Yost. Pansy Neal celebrated her 99th birthday during the time this book was written. (Courtesy of Pansy Neal.)

On Easter Sunday 1950, the Neal family stopped for a picnic at their Virginia Avenue home before going to services at the First (United) Methodist Church. They are, from left to right, Bill, Pansy, and their daughters, Betty, Lois, and Dorothy. (Courtesy of Pansy Neal.)

Ted Yost and Betty Neal visit at the Neal home on Virginia Avenue in the days before their marriage. Little sister Dorothy (background) kept close watch even though Ted was known to pay her to leave the young couple alone. (Courtesy of Pansy Neal.)

Pansy and Bill Neal were a typical wartime couple during World War II. While Bill was on a furlough at their home in Bluefield in 1943, this photograph was taken. (Courtesy of Pansy Neal.)

Outstanding civic leaders in Bluefield, Virginia, pictured at the old town hall in 1952, were, from left to right, town manager W. N. "Pick" Lambert, town treasurer C. P. "Perk" Painter, and chief of police J. B. "Brit" Brown. Historic records tell of an early mayor, J. M. Smith, who served for 12 years. His chief of police was Grayson Hall, who served for 21 years. (Courtesy of Margaret Davis Ratcliff.)

Hudson Huffard, prominent business and civic leader and mayor of Bluefield in the 1950s, is pictured with other community leaders. From left to right are (seated) Murray Pope, Huffard, and Earl Peery; (standing) Okey Yost and W. M. McGlamery. (Courtesy of Margaret Davis Ratcliff.)

From left to right, Sallie Sanders, Vicie Greever Sanders, Allene Sanders, and Mary Easley Sanders visited together at the historic Sanders home, now owned by the Graham Historical Society. The beautiful old house has been saved from destruction originally in the plans for the building of the new highway Route 460 and new business development. The adjoining Leatherwood Farm was divided by the highway, but it is still in operation and continues to produce world-champion Saddlebred horses. (Courtesy of Graham Historical Society.)

Bluefield Town Council members in 1966 were, from left to right, Richard Cooley, Ryland Wiesiger, William McGlamery, Harvey Tate, and Frank Denardo. Bluefield has always been known for its dedicated civic leaders, including earlier times when the leaders were from Pin Hook and Harman. History records the establishment of a post office named Harman in 1880. John and Ann Mustard Harman were the first of that name to come to the area in 1874. (Courtesy of Graham Historical Society.)

Henry Clay Callaway, one of Bluefield's outstanding mayors, was also well known for his newspaper column called "The Old Timer," published in the *Bluefield Daily Telegraph*. He worked for many years as a telegrapher for the Norfolk and Western Railway. (Courtesy of Graham Historical Society.)

Mary Jane Davis Painter is a reminder of the strength of the women who raised their families in early Tazewell County, in the days when Graham was called Pin Hook or Harman and the economy following the Civil War was uncertain. Her husband was James Bell Painter, a Civil War veteran. The Painter family has lived in Graham since about 1921. They moved from the Dial Rock area. (Courtesy of Margaret Elam.)

Jimmy Jones has combined education and civic duties in his careers in his hometown. He is retired from Graham High School as the popular and dedicated band director. He has served as the mayor of Bluefield, Virginia, and as a member of the town council. (Courtesy of Debra Waugh and Graham High School.)

A great honor came to Graham High School in 2003 when Drew Marrs was named youth governor of the Virginia Model General Assembly. Marrs (right) received congratulations from Gov. Mark Warner. Students from high schools across the Commonwealth elected Marrs. (Courtesy of Drew Marrs.)

Another honor came to Graham High School in 2008 when Yiu Fung "Marco" Leung was named Virginia Model General Assembly youth governor. Marco (right) received congratulations from Gov. Timothy Kaine. Other high school students from Tazewell County and the state of Virginia chose Marco for the honor. (Courtesy of Yiu Fung "Marco" Leung.)

Peggy Jackson Farmer (left) and Dolly Jackson Sherman smile for the camera in October 2003. They are associated with the well-known Lisa's Barber Shop in Bluefield, owned by Lisa Wolkoff. The barbershop was named Bluefield's "business of the month" in January 2003 and the "business for the quarter" in 2006. (Courtesy of Lisa's Barber Shop.)

Charles Wesley Matthews of Bluefield, a Civil War veteran, celebrated his 100th birthday with a Navajo tribe to whom he traced his ancestry. At his death in 1950, he was 105 years old, the oldest Civil War veteran in Virginia. His many adventures included traveling west in a wagon train and being on duty at Appomattox when the war ended. (Courtesy of the Dudley family.)

Jack Asbury served as Bluefield's chief of police, and he is well remembered for his dedication and leadership in the town's law enforcement. He is pictured in his office in the old town hall building. In his honor, the Jack Asbury Park has been established. (Courtesy of Karen Woody, Marcia Muncey, and Graham Middle School.)

The wedding party at the marriage of Walter Sanders and Vicie Greever must have been a highlight of the Graham social season. This picture could be a study in the styles of dress, for men and women, close to 1900. (Courtesy of Robert Perry.)

The Bluefield Town Council and town employees, pictured at the old town hall in the 1950s, included, from left to right, (seated) Okey B. Yost, Ruth Perdue Wallace, J. Hudson Huffard, Margaret Davis Ratcliff (who served the town as secretary from 1950 to 1991), and William McGlamery; (standing) Murray Pope, J. R. Barnett, Judge J. C. Evans, W. N. Lambert, Earl Peery, Paul Goodman, J. B. Brown, and M. Crockett Hughes. At this time, Huffard was the mayor. His father, S. N. Huffard, founded the Chicago House Furniture Company in 1890, and he, along with his helper Frank Roy, initially traveled to sell the home furnishings. Their efforts developed into one of the region's most prestigious businesses. J. Hudson Huffard later served as company president. (Courtesy of Margaret Davis Ratcliff.)

Andrew M. Henry, a faithful member of the Bluefield Town Council for many years, was the first African American elected to the council. The Henry family included community leaders in Bluefield for years. (Courtesy of Eva Saunders.)

The Hamilton family of Bluefield looks happy in this recent picture. From left to right are (first row) Jan Hamilton Gray and Maggie Palmer Hamilton; (second row) Marie Hamilton, Angela Hamilton, and Melanie Henry. (Courtesy of Eva Saunders.)

James H. McNeer Jr. and Helen Baylor were married in 1927, and the groom is pictured dressed for his wedding. McNeer's parents were James H. and Edith McNeer of Bluefield, and the bride was the daughter of J. E. and Eliza Baylor of Wardell. The wedding ceremony was performed by the Methodist minister, the Reverend Roy E. Early. James H. McNeer and his brother, Edwin A. "Bus" McNeer, founded the New Graham Pharmacy in 1935. (Courtesy of Dr. James B. McNeer.)

Four Bluefield businessmen were honored in 1941 by the chamber of commerce for having been in local business for 50 years or more. They were, from left to right, John Emory Bailey, W. L. Nash, O. A. Metcalfe, and S. N. Huffard. (Courtesy of Dr. James H. McNeer.)

Blair Ward Frazier (1881–1955) reads to three of her four children in the year 1911. They are Sallie (left), Ward (center), and Betty. Another son, Will, was born in 1912. Blair Ward grew up in Ward's Cove and in the school year of 1904–1905 was a high school teacher in Graham. She married William McTyer Frazier (1872–1954) of Bluefield in 1905. He owned a store on the present site of the First United Methodist Church and was later an accountant for Thistle Foundry. They lived on Tazewell Avenue. About 1920, they moved to Kennewick, Washington. (Courtesy of Robert Perry.)

25

Laura Davenport, one of the "McCall Sisters," children of Mary George and Jeff McCall, served the Town of Bluefield as treasurer for six years. She was the first woman to hold a local municipal office. She looked at the "new" town hall and remarked that it was built on the site of her father's home when the McCalls first moved to Pin Hook. The family came from Witten Valley in the 1880s. (Courtesy of Robert Perry.)

Sally Litz brought grand opera to Bluefield when her singing career earned her the title "the southern nightingale" in 1926. The soprano was enthusiastically acclaimed by audiences throughout the United States. Her song was the first to be heard from continent to continent when international radio broadcast her voice from North America to Europe. (Courtesy of Ellen C. Miller.)

Clarence Smith, well-known Bluefield and Tazewell County attorney, served as town attorney in the 1930s. At the time of his death in 1955, he was a law partner with Hubert Peery of Tazewell. He was the county's first trial justice and also later served as the Tazwell County's Commonwealth's attorney. (Courtesy of Ellen Miller.)

George Peery Crockett (1879–1933) was a prominent Bluefield attorney whose influence lives on in his church and community. He was a faithful member of the old Graham Methodist Episcopal Church and a lawyer known for his wisdom and kindness. He was admitted to the bar in 1901 and first practiced in the Crockett and Crockett law firm, later changed to Crockett and Sanders. He was a son of R. G. and Margaret Eliza Crockett of Graham. (Courtesy of the Reverend Dr. Don Scott.)

M. Crockett Hughes, a lifelong resident of Bluefield, served as town attorney in the 1950s and also served as an official county attorney. Another Bluefield attorney and judge who served about the same time was Vincent L. Sexton. He was Tazewell County circuit court judge from 1946 until 1976, and it was written in the *Clinch Valley News* that "he served for 30 years with integrity, fairness and wisdom." (Courtesy of Ellen C. Miller.)

A 1936 get-together for this group of well-remembered ladies included, from left to right, Sarah Osborne, Ellen Dunn Callaway, Ann Osberne McNeer, Lorine Callaway, and Virginia Osborne. (Courtesy of Ellen C. Miller.)

At the Bluefield Community Christmas Tree in 1952, Santa Claus made these three boys very happy. They include, from left to right, Everett Murray Callaway, Richard Henry Callaway, and Ronald Osborne. (Courtesy of Ellen C. Miller.)

Pearl Murray Callaway and her dog, Trixie, relax in their outdoor living room at their home on Tazewell Avenue. A bank outside the Callaway home was excavated and converted into a rock terrace. The pool and flowers made it a unique place of beauty. (Courtesy of Ellen C. Miller.)

Josephine Pinson (left) and Blaine W. Harman were married in 1923. They moved to Bluefield in 1927 and lived in a beautiful home on Crescent Street. Their two daughters are Joann Harman and Gail Harman Williams. Members of the family still live in the home, which is adjacent to Harmony Acres swimming pool. (Courtesy of Joann Harman and Gail Harman Williams.)

A handsome young Clyde Bowling looks ready for his lifetime of volunteerism in Bluefield and Tazewell County. He has worked tirelessly for better primary and secondary roads in southwest Virginia and at the same time promoted the building of U.S. Route 460. His name is always connected with the statewide efforts of water and soil conservation programs, and he has been honored for this important work many times. The Bluefield Business and Professional Association recognized his community service as "the epitome of volunteerism in the community." (Courtesy of Joyce Buchanan.)

The three Whitenack sisters were all valedictorians of their graduating classes at Graham High School. Pictured from left to right are Mary Francis Chappell, Betty Sue Alexander, and Peggy Ruth Scott. Their mother, Ewilda Wheeler Whitenack, was also valedictorian of her high school class in Princeton. (Courtesy of the Reverend Dr. Don Scott.)

Paul and Ewilda Whitenack, longtime residents of West Graham, were known for their dedication to the community and church. They were active members of the Virginia Avenue United Methodist Church. Paul Whitenack's reputation as an expert automobile mechanic will long be remembered. Their three daughters are Mary Francis, Betty, and Peggy. (Courtesy of the Reverend Dr. Don Scott.)

Edward Thomas Scott and Lucy Anna Belle Reynolds were married December 24, 1885. Ten children were born into that family. From left to right are Anna Belle, Bill, Luther, Earle, Robert, Mae, Sarah, Pearl, Frank, and Ethel. Several of these children lived and worked in Bluefield, Virginia. Anna Belle Scott Summers is the only living child, and she was 100 years old on February 1, 2009. (Courtesy of the Reverend Dr. Don Scott.)

The Fisher-Trenton Pharmacy on Virginia Avenue was a well-known drugstore in the mid-1900s that had, among other things, the counter where customers of all ages enjoyed food and drinks while waiting for their prescriptions to be filled by Paul Trenton, pictured here. (Courtesy of Nancy Trenton.)

"Bus" McNeer and the New Graham Pharmacy were always a special part of Bluefield. He and his brother, James McNeer, were co-owners of the Virginia Avenue business. James died at an early age, and Brisco Carlin, a West Virginia pharmacist, assisted in the prescription department in the family's time of need. The New Graham Pharmacy continues today in the fine tradition started by the McNeers in 1935. (Courtesy of Nancy Trenton.)

Dr. T. P. Ferraccio is remembered as a beloved family doctor in Bluefield. It has been said by many patients that he was more than a healer; he was a friend to those under his care. (Courtesy of Nancy Trenton.)

Jack Litz was postmaster in Bluefield, Virginia, for many years. He was also a faithful member of First United Methodist Church and served as Sunday school superintendent. (Courtesy of the Reverend Dr. Don Scott and Nancy Trenton.)

Angelo Monaco was a pharmacist at the Fisher-Trenton drugstore in the 1950s. The popular pharmacy was a respected Bluefield business on Virginia Avenue. (Courtesy of Nancy Trenton.)

Frank Denardo (left) and his wife, Bonnie Amato Denardo, pose at their home on Franklin Street in Bluefield. Bonnie stands among the flowers in their backyard. In the early 1900s, Frank Denardo, a native of Italy, was a shoe maker and an importer of the valued visca hats. He immigrated to America at age 16. The Denardos first lived in the section of wooden houses that lined Bluefield's Virginia Avenue, which was called Main Street at that time. (Courtesy of Dolores Denardo Pritchett.)

The four Denardo children are pictured at the home of their parents, Frank Sr. and Bonnie Denardo. They are, from left to right, (seated) Frank Jr. and Pat; (standing) Carmel and Dolores. (Courtesy of Dolores Denardo Pritchett.)

Fred Amato Sr. (1865–1942) and Raffaela Cicalese (1967–1966) were married in Italy in 1889 and came to America on their honeymoon. They stayed in this country and eventually settled in Bluefield. Fred was a contractor for the early railroads, and he assisted in the building of the Clinchfield, Carolina, and Ohio rail lines. The Amatos ran the old Virginia Hotel on Virginia Avenue. There was another old hotel on College Avenue owned by Maxie Witten. It was one of the early buildings that burned in Graham. (Courtesy of Dolores Denardo Pritchett.)

M. Ervin Rich and his wife, Martha Lou Neel Rich, moved into the John L. Neel home in 1942. They were married in 1929 and had two sons, Ervin Jr. and Neel. The six generations who have lived in the historic home include John Lewis Neel, William Bane Neel, Martha Lou Neel Rich, M. Ervin Rich Jr., William Ervin Rich, and Daniel William Rich. (Courtesy of Ervin Rich.)

James F. Dudley was born in the vicinity of Falls Mills in 1860. He was the son of Hugh Dudley, who died in West Graham in 1911. James F. Dudley, at age 22, was a carpenter and helped build the first houses in town in 1881. His career spanned many areas in Graham: farmer, merchant, and as part of Dudley and Fink, the meat and grocery business. He was a staunch Democrat, a member of the Clear Fork School Board in 1913, a member of the Graham Christian Church, and a leading member of the Masonic Lodge. In 1884, Dudley married Evelina Tabor. (Courtesy of the Dudley family.)

Members of the Spracher family of West Graham are David B. (seated left) and his wife, Margaret S. (Lucas). Standing are their children Dorothy S. ("Dot") and David E. ("Dave"). (Courtesy of John Spracher.)

37

Twin sisters Ann L. (Greever) Spracher (left and Elizabeth S. (Greever) Hudson Spangler Lambert pose in the front yard at the Montrose Street home of Kate Spracher Graybeal. Ann and her husband, William L. Spracher, were natives of Burkes Garden who came to West Graham in its earliest days after raising their family in Baptist Valley. (Courtesy of John Spracher.)

Andrew Jackson Dudley lost a leg while fighting in the Civil War in the 1860s. His brother was Hugh Dudley, and they lived in the Bluefield and Falls Mills area. The brothers are ancestors of the Dudleys who live in Bluefield today. (Courtesy of the Dudley family.)

James Glen Dudley (left) and Charles Hugh Dudley were curious about the picture-taking process around 1900. The photographer was P. W. Poff, who took many family pictures in the early 1900s. (Courtesy of the Dudley family.)

Margaret Dudley, the daughter of Hugh Dudley, was beautifully dressed in this special photograph taken in the 1880s. In more modern days, she could be a model with her perfect coiffure and clothing and her tranquil expression. (Courtesy of the Dudley family.)

39

James F. Dudley Sr. (1899–1933) was a leading member of the Graham community during his short life of 32 years. He was the youngest son in his immediate family. (Courtesy of the Dudley family.)

Becky Combs Richardson is a noted Bluefield artist who has taught students for more than 30 years. She has influenced students of all ages to see the beauty that surrounds them and to express their deep feelings through the world of art. (Courtesy of Stephanie Rose Musick.)

Two
On the Home Front

The historic Sanders House, built by Walter M. Sanders, is now the home of the Graham Historical Society. Completed in 1896, the house still has its solid oak woodwork and some of the original furniture that belonged to the Sanders family. The granary, smokehouse, and cottage outbuildings have been renovated and now include a railroad museum and the Tazewell County Visitors Center. (Courtesy of Walter M. Sanders III, featured in Images of America: *Tazewell County*.)

The old Flumer/Vanhoozer house was believed to be the oldest house in Bluefield. This view is from the nearby creek, and Annie Dudley is walking in the yard among the flowering bushes. In the blizzard of 1993, the house collapsed. The date of the building is unknown. (Courtesy of the Dudley family.)

This house on Greever Avenue was the residence of the Painter family when they moved to Bluefield from Bluff City in 1921. The Painter family has long been leaders in the community. (Courtesy of Margaret Elam.)

This Logan Street home of Dr. Henry Bowen Frazier and Florence McCall Frazier was built in 1905. In this 1908 photograph are Florence (1878–1946) and the Frazier children: from left to right, twins Virginia and Lucian, McCall, and Henry. Dr. Frazier practiced medicine in Graham from 1898 until his death in 1940. Florence Frazier's father, Jesse M. McCall, was the second mayor of Graham in the 1890s. The McCall and Frazier families played a vital role in the development of Graham for over 60 years. They were active in the First Methodist Church, and a plaque at the church commemorates the service of Dr. Frazier. (Courtesy of H. B. Frazier III and the Ed Blair family.)

Often called the Dudley Cabin, this log structure was built in the 1880s by the Charles Tabor family of West Graham, ancestors of James W. Dudley and Glen Tate Dudley. The first of the Dudley family came to Falls Mills in the mid-1800s, and later family members moved to Graham. (Courtesy of Graham Historical Society.)

The Bane-Benbow home, one of the oldest in Bluefield, Virginia, has always been a showplace amid many beautiful houses, old and new. It has been occupied by families of Banes, Benbows, Gillespies, Andes, and Ammars. Dr. J. G. W. Gillespie and his family lived here on two separate occasions. (Courtesy of Graham Historical Society.)

The Ammar (Bane-Benbow) home has a winding stairway of unusual beauty. At the bottom is a hollow newel post where the early occupants hid their valuables. (Courtesy of Graham Historical Society.)

The John P. Cameron family lived in one of Graham's early homes, built in 1898 by John Spracher. They are, from left to right, (seated) Julia Cameron, Alexander Main, Mary Main Cameron, Christina Cameron, Christina Main Melom, John P. Cameron Jr., Margaret Jane Cameron, and Ethel Main Cameron; (standing) John Patterson Cameron, holding Mary Moore Cameron. The first Camerons came to Graham in 1862 with the establishment of the Virginia Lumber Company. Later John P. Cameron took over the Thistle Foundry, founded in 1898, from owner Sam Litz. The Litz family located at Graham about 1891. John Farquharson, now retired, was a later owner and manager of Thistle Foundry. (Courtesy of Graham Historical Society.)

The James Pile home on Virginia Avenue was built in the east end of Bluefield and has a unique architectural style that blends with the new and old homes in the neighborhood. (Courtesy of Graham Historical Society.)

John L. Neel and his wife, Martha Ann Harman, built this historic house in 1875–1876, and up to 2008, six generations have lived in the beautiful brick home. After the Civil War, John Neel returned home and started his building project. Bricks were made in the yard, and lumber was sawed and dried on the farm. All the doors, windows, and trim were handmade. The only bought materials were glass, door hardware, and nails, and they were brought by horse and buggy from Lynchburg. Water for the family came from a well dug in the side yard. This was used until the Town of Bluefield provided them water in exchange for a spring, which was used for the town water supply. The Ervin Rich Jr. family occupies the home now. (Courtesy of Ervin Rich and Graham Historical Society.)

The B. W. Harman home is a stately building constructed in the late 1800s by the Leedy family. A modern addition close by is Harmony Acres swimming pool on the site of an old mill. E. Harve Harman, a prominent Mason, came to Graham in 1874. He held every office in the Harman Lodge and was honored as a 50-year Mason. He was the first undertaker in Graham and was known for his white hearse and team of white horses. (Courtesy of Graham Historical Society.)

The J. H. Blackwell house on Virginia Avenue was built in the 1800s. It is one of the oldest residences still occupied by descendants of the original builders. (Courtesy of Graham Historical Society.)

The J. F. Dudley home place keeps alive memories of the prominent family who were listed among the early citizens of the area. In 1915, Dudley and Frazier were Graham grocers. J. S. Dudley was the town's mayor in 1901. In recent years, the family's interests have included the Dudley Memorial Mortuary and the well-remembered Dudley primary school. Attorney Jim Dudley was an active member of the Tazewell County School Board in recent years. (Courtesy of Graham Historical Society.)

The Jake Routh home on old Fincastle Turnpike was built in the late 1800s. The double porch is a unique addition to its beauty. (Courtesy of Graham Historical Society.)

The home of the John Crittendon Harman family, at the corner of Virginia Avenue and Greever Avenue, was pictured on a summer day in the late 1920s. The Harman family name has been prominent dating back to the time when "Harman" was the second name of the town, following "Pin Hook" and preceding "Graham." (Courtesy of Venture Printing and Office Supply and David Moore.)

This cabin stood across the road from the present historic Sanders home. It was built in the mid-1800s, and the family of Walter M. Sanders lived here before the new house (now the Graham Historical Society) was completed in 1896. The cabin burned a few years later, and a fine collection of walnut furniture, left inside when the family moved, was destroyed. (Courtesy of Lisa's Barber Shop.)

The home of C. W. Matthews, Civil War veteran, stood on Main Street in Graham. The building was also Catron's Tea Room at a later date, operated by Juliett Catron, a daughter of Matthews. (Courtesy of the Dudley family.)

The Henry C. Callaway residence was on High Street in West Graham. His wife was Pearl Murray Callaway. It is easy to imagine the couple inside their comfortable home editing his popular newspaper column for the *Bluefield Daily Telegraph* called "News of the Virginia Side" by the "Old Timer." (Courtesy of Ellen C. Miller.)

The Bill Osborne home place was a good example of the architecture of the late 1890s or early 1900s. Osborne is a respected Graham resident who has long been an avid supporter of his hometown. As a young man, Osborne joined the workforce at Chicago House Furnishing Company, established in 1890. At the time of his employment, there were 12 salesmen in the field, and two in house, at the growing business. (Courtesy of Graham Florist and Teddy Gearhart.)

Frank and Bonnie Denardo built their home on Franklin Street in 1924. Bonnie stands at the entrance to the beautiful property. The Denardos were among the early settlers in Bluefield. (Courtesy of Dolores Denardo Pritchett.)

"Bailey Log House."

The Bailey log house was built by Harvey Bailey prior to 1861. It has been located in several places, but now the Graham Historical Society will give it a permanent home. The house will be reassembled and placed in the Jack Asbury Park overlooking downtown Bluefield, Virginia. The Bailey family settled along the Bluestone River in 1770. Richard Peyton Bailey Sr. was the first of the family to homestead in the area. The cabin was sketched here by the Reverend Dr. Don Scott. (Courtesy of the Reverend Dr. Don Scott.)

This Victorian farmhouse, constructed by family members in 1905, served as the Spracher home place for five generations. The town of Bluefield grew around the Spracher reservation, which was specifically selected for its abundance of spring water for livestock. This stately home, with its extraordinary pre-blight chestnut woodwork, still stands as a beacon over the West Graham community. (Courtesy of John Spracher.)

Three

VIRGINIA'S TALLEST TOWN

The Virginia Department of Historic Resources marker details a brief history of Bluefield, Virginia. It notes that the town of Graham was first incorporated in 1884. (Courtesy of Karen Woody, Marcia Muncey, and Graham Middle School.)

The Bluefield Monument Company, built in 1922, continues to be one of the town's most successful businesses. Its sign advertises "memorials of character." It is currently owned by Gary Neal, who has been associated with the company for 25 years. (Courtesy of Craft Memorial Library and Eastern Regional Coal Archives, Bluefield, West Virginia.)

These unidentified artisans are busily engaged in the quality craftsmanship of stone engraving at the Bluefield Monument Company on Virginia Avenue. This family-owned and -operated business has exhibited workmanship and innovation in the stone engraving industry for nearly a century. (Courtesy of Bluefield Monument Company and Gary Neal.)

The prestigious Masonic Lodge was chartered in 1888, and the ornate building was constructed in 1895 to replace a frame building that burned the same year. At the present time, the Lodge uses the two upper floors and the popular New Graham Pharmacy occupies the lower floor. The first Worshipful Master of the Harman Lodge No. 222 was "Uncle" Zack Witten, a prominent Graham leader. Graham also had another Masonic Lodge (Graham Lodge No. 324) organized in 1914. One of the early proprietors of the old Graham Pharmacy was W. C. Fisher, listed as a Mason in 1915. (Courtesy of Margaret Elam.)

In early 1941, the Bluefield, Virginia, post office was under construction. "Depression art" decorates the interior of the lobby. This was done by government-sponsored artists who needed work during the hard times following the national Depression. Today the work in post offices is regarded as folk art of the highest caliber. The Bluefield mural was done by artist R. N. Kenah in 1942 with the title "Coal Mining." The national arts project was created in 1934 under the Treasury Department's Section of Fine Arts. The speaker for the 1941 opening celebration was Virginia governor James Price. (Courtesy of Margaret Elam, Venture Printing and Office Supply, and David Moore.)

The interior of the old Bank of Graham in 1915 appears to have machines as complicated as modern computers. The bank was located on the corner of Virginia Avenue and Spruce Street. The banker in the middle is Curtis Shufflebarger, a well-remembered Tazewell County businessman. The other two employees are unidentified, but earlier cashiers at the bank were W. V. Wilson, Lee J. Barbee, J. C. Davenport, J. E. Morton, and R. K. Crockett. The bank property was the site in 1898 of the popular hotel, the Graham House. Rooms were $1 a day, and meals were 25¢. (Courtesy of Margaret Elam.)

The Bluefield, Virginia, city hall and jail were located in this small building in 1924. It was at the corner of Walnut Street and Virginia Avenue. A more modern town hall was built in 1952. Unfortunately the property was subject to severe flooding through the years. In 2004, a beautiful new municipal building was constructed in the Double Gates section of town, on Huffard Drive. The old building was demolished, and now the Jack Asbury square occupies the site. The square honors the former police chief who served for 25 years. (Courtesy of Margaret Elam.)

Hotel Graham, built in the 1880s, was a landmark for the growing town. In the early days, it was a popular destination for travelers and visitors to the nearby coalfields. "Drummers," who sold merchandise throughout the area, often made Hotel Graham their headquarters. Note the long porch, typical of public buildings in the 19th century. In March 1896, the beautiful hotel was destroyed by fire. The show place was patterned after the well-known Hotel Roanoke. (Courtesy of Margaret Elam, Venture Printing and Office Supply, and David Moore.)

The Graham Railroad Station was an important part of the town when coal was king and the prospects for Graham included immediate growth and prosperity. This was changed when the railroad center was moved to the West Virginia location. When the first railroad was built to Pocahontas in 1883, Thomas Graham came from Philadelphia and invested heavily in the area. The town name was changed from Harman to Graham in his honor. In 1896, the Norfolk and Western passenger station was destroyed by fire. (Courtesy of the Norfolk and Western Historical Photograph Collection at Virginia Tech.)

The handsome railroad station at Bluefield, Virginia, was built when rail traffic was important in the nearby coalfields. The original Graham station was replaced with the Bluefield, Virginia, logo in 1924. Passenger train traffic was heavy up into the mid-1930s, when the popularity of automobiles changed the travel habits to some degree. Interest in the railroads caused Thomas Graham and F. J. Kimball to invest heavily in the growing Graham area. The town took the name Graham. Kimball established the Furnace Company and Hotel Graham. In the 1880s, both developers believed Graham would be the heart of the railroad growth from the thriving coalfields. (Courtesy of Joann Harman and Gail Harman Williams.)

The Norfolk and Western switch tower was part of Graham in the days when it was a booming railroad town with great anticipation of rapid growth. Plans were for Graham to become the junction for the Clinch Valley line and the Pocahontas division of the railways. During the boom time, the Graham Furnace Company was established and the beautiful Hotel Graham was built on Graham Heights. Builders of the Furnace Company and the Hotel Graham were John and Walter Graham, sons of Thomas Graham, and F. J. Kimball, president of the railway. Pictured at the switch tower are H. C. Callaway (left) and an unidentified assistant. Callaway was the telegrapher for the railroad for several years. (Courtesy of Graham Historical Society.)

When the First National Bank was built in Graham during the 1920s, it was considered one of the finest buildings in town. A group of potential investors join the workers in watching the construction work. Note the unpaved road and the typical houses of that era. It is currently the location of Four Seasons Wireless Company. This modern business illustrates the great change in the business climate in almost a century. (Courtesy of Lisa's Barber Shop and Graham Historical Society.)

When the first streetcar came to Graham in 1908, it helped the citizens who looked forward to traveling in greater comfort. This street scene may be shortly after the tracks were built by the Bluestone Traction Company. The streetcar came from West Virginia and ended in West Graham. Later known as the Bluefield and Hinton Electric Railway Company, the line eventually became part of the Tri-City Traction Company, whose tracks extended from Bluefield, Virginia, to Princeton, West Virginia. The streetcars were discontinued in 1936. (Courtesy of Anthony Stephens and Lisa's Barber Shop.)

The former town hall building was completed in 1952 and occupied a block in the center of Bluefield. Town officials at the time of dedication included C. P. Painter, treasurer; W. N. Lambert, manager; J. Clark Evans, trial justice; M. Crockett Hughes Jr., attorney; J. Brit Brown, chief of police; and J. R. Barnett, fire chief. The building was demolished because it was subject to frequent flooding. (Courtesy of Robert Perry and Margaret Elam.)

During the 2001 flood, Venture Printing and Office Supplies was one of the affected buildings. Bluefield shoppers will remember the former Rasi's Grocery in the background. Venture Printing moved to a new site on Virginia Avenue. Between the years 2000 and 2005, there were seven floods within town limits. (Courtesy of Venture Printing and David Moore.)

Dudley Memorial Mortuary and the Wartburg Lutheran Church were combined to make the present funeral home in 1953. The Lutheran church was built in 1907, and at that time, many Lutheran church members moved into the Bluefield area. The construction is underway in this picture. Sometimes it is called "the funeral home with the church chapel." (Courtesy of the Dudley family.)

Cotton's Drive-In has filled the appetite needs of the Bluefield area for generations of both the young and old. This interior picture with the two unidentified men was taken before the business moved to its present location in West Graham. An early advertisement mentions its "pure milk and ice cream." Another well-remembered eatery was Jake's Place, run by Jake Sexton. (Courtesy of Venture Printing and Office Supply and David Moore.)

H. B. Breckenridge, Graham photographer, preserved many of the early town's images, perhaps unknowingly, when he was asked to take pictures. This flood scene in the Graham business district was one of many he took during the multiple times the floodwaters covered the area. To the left is the Ford dealership, Bluestone Motor Company. (Courtesy of Lisa's Barber Shop, Venture Printing and Office Supply, and David Moore.)

Industry moved into early Graham soon after the nearby coalfields opened. It expanded rapidly in a few years. This pictures some of the industrial complex with three of the important first industries named: Thistle Foundry, Keys Planing Mill, and Seyler Lumber Company. (Courtesy of Lisa's Barber Shop.)

The streets had not been paved, but motor travel had come to early Graham in this scene in the mid-1900s. When the first residents needed to travel at the dawn of the 20th century, especially between Graham and Bluefield, West Virginia, the easiest way was by train. Even before any safe roads were built between the two cities, a man named Pleasant Young ran an old hack to provide transportation. (Courtesy of Lisa's Barber Shop.)

V. L. Burress operated the Graham Transfer business in 1912 and for years following. He is pictured, at age 22, with his decorated wagon and horse on the Fourth of July in 1912. Even on this special occasion, he is hauling materials. (Courtesy of Lisa's Barber Shop.)

It is believed this is a Ferris wheel on Virginia Avenue (called Main Street) in the year 1924. The Ferris wheel was invented in 1893 by George Ferris for a Chicago Exhibition. Was a circus or a carnival coming to Bluefield? Otherwise, how did a Ferris wheel end up on Main Street? After all, a carnival is not a carnival without a Ferris wheel. (Courtesy of Lisa's Barber Shop.)

The Virginia Confectionery Company was a busy place in early Graham almost a century ago. Homemade bread was one of the company's premier products. W. J. Cole, a well-known businessman, and the Cole family have long been connected to the Bluefield/Graham business scene. (Courtesy of Lisa's Barber Shop.)

The Graham Furnace Company was one of the first major industries to be built in Graham. The towering smokestack was a landmark, still remembered by some residents. The company was located in West Graham, and in 1891, it had a capital of $300,000 and the furnace had a capacity of 150 tons daily. This picture was taken in 1925. (Courtesy of Lisa's Barber Shop.)

The Pocahontas Air Transport Company served Bluefield's small plane traffic from 1930 to 1950. The airstrip was on the present site of the City Park. The air shows at the site attracted large crowds and many celebrities, including Amelia Earhart, who was lost at sea on a transatlantic flight shortly after her appearance. (Courtesy of Craft Memorial Library and Eastern Regional Coal Archives, Bluefield, West Virginia.)

This horse and buggy was one of the entries in a horse race at the City Park, probably in the 1930s. The proud driver is unidentified. (Courtesy of Craft Memorial Library and Eastern Regional Coal Archives, Bluefield, West Virginia.)

The Callaway Building in Bluefield was located on the corner of Walnut Street and Virginia Avenue. Built by Robert Callaway in the 1920s, it was used for a motion picture theater. Other theaters remembered in the town were the Gem Theater of 1915 (managed by R. L. Sutherland) and the Lee Theater, which was established later in the town's history and burned in 1950. (Courtesy of Ellen C. Miller.)

The Bane Block building had as occupants several Graham businesses in the early 1900s. Two pictured are Graham Hardware Company and Porter and Ritter Company. (Courtesy of Graham Floral and Teddy Gearhart.)

At the dawn of the 20th century, Virginia Avenue was still unpaved, but the pole on the right means electricity had come to town. The trolley tracks are also visible in the middle of the avenue. (Courtesy of Robert Perry.)

Helen Baylor McNeer and Cary Benbow posed for this picture in 1908 at the old Graham Pharmacy. This image provides a unique glimpse inside the old drugstore. Helen dressed up for the special occasion. A few years after this pose, Helen was one of the last ladies to be crowned "Miss Graham." (Courtesy of Dr. James B. McNeer.)

The Mansure Textile Company operated in Bluefield between the 1940s and 1960s with a large workforce. This picture, taken in 1949, includes, from left to right, (seated) Nellie Doss, Nancy Tabor, Charlie Van Wie, Elsie Shrader, Evelyn Ritter, John Johnson, and Elmo Reed; (standing) Mae Tabor, Lucille Seal, Edith Tabor, Anna Mae Lilly, Cassie Rancis, Nannie Taylor, Dora Collins, Gladys Davidson, Otis White, Ethel McGrady, Dollie Caudill, Irene Mansure, Joann Harman, Mildred Mathena, Darliss Wriston, and Virginia Richardson. (Courtesy of Joann Harman.)

Neel's Grocery was an important part of Bluefield in the 1940s and 1950s, and this picture indicates much activity at the West Graham store. The Double K Market was later in the same location. Neel's Grocery was owned and operated by brothers Otis and Raymond Neel. The Double K was owned and operated by Howard Kitts and Byron Kesler. (Courtesy of Graham Floral and Teddy Gearhart.)

J. P. Cameron (left) and William M. Frazier were hard at work in the office of the Thistle Foundry, a thriving early business. Dr. H. B. Frazier came to Graham in 1890 and is listed among the early pioneers in the area. The Camerons originally came from Scotland. (Courtesy of Robert Perry.)

The houses on Walnut Street were repeatedly damaged by flooding of the Beaver Pond Creek. This view is from Tazewell Avenue. The houses were torn down, and the lots behind the First United Methodist Church and the Rodriquez-Bluefield Funeral Home (formerly Wagner Funeral Home) now stand vacant. (Courtesy of Ellen C. Miller.)

The business district of Graham in the 1920s included the Chicago House Furnishing Company on the distant right. Across College Avenue stands the First National Bank building and the Morton Building. The Morton Building included several businesses on the first floor and the Osborne Kindergarten on the second floor. Note the vintage automobiles making their way down the flooded Main Street, now Virginia Avenue. (Courtesy of Joann Harman and Gail Harman Williams.)

Chicago Furnishing Company, founded by S. N. Huffard in 1890 as the Graham Furniture Store, was a dependable business and landmark in the heart of Bluefield. The building is no longer standing, with the town park now on the site. (Courtesy of Karen Woody, Marcia Muncey, and Graham Middle School.)

The modern gazebo in the town square (Graham Square) is the scene of many Bluefield activities. Often local musicians entertain here at special events for the entire community. The square has often been the focal point of the popular Autumn Jamboree. (Courtesy of Mullins files.)

Among early Graham businesses were several bottling companies. This bottle is the 3-C Nectar drink with the Graham, Virginia, label clearly visible. The bottler was the Crystal Bottling and Cider Company of Graham, first incorporated in 1904 with Will Mitchell as president. Other Bluefield bottlers included the Nehi Bottling Company, which began between 1927 and 1930 on Tazewell Avenue with Hugh Falls as president. Royal Crown Cola was bottled by Nehi beginning in 1937 with Pres. A. F. Higgins. The Falls Mills Bottling Company manufactured several flavors of the famous "Pocahontas" soft drink brand. (Courtesy of Joseph Lee.)

The mural at the Bluefield Post Office is a focal point for folk artists who recognize the value of the works created by government-supported programs for unemployed artists during the Great Depression. This mural is entitled *Coal Mining* and was created by Richard Hay Kenah, artist for the Treasury Department's Section of the Fine Arts, in 1942. (Courtesy of Mullins files.)

The artist of the Bluefield Post Office's interior also painted the murals for the Louisburg, North Carolina, Post Office (*Tobacco Auction*) in 1939 and the Bridgeport, Ohio, Post Office (*Ohio Harvest*) in 1940. Kenah also submitted proposals for the post offices at Pittsburgh, Pennsylvania, and Norfolk, Virginia, during the Depression years. (Courtesy of Mullins files.)

Kelly Kyle Witt operated Witt's Grocery on Virginia Avenue in the early and mid-20th century. Before entering the grocery business, he was a shipping clerk for an early Bluefield bakery for 17 years. He married the former Georgia VanDyke of Tazewell County. They had three daughters, Nellie Witt Doak (Steele), Dorothy Witt Tabor, and Roselyn Witt Workman. An early newspaper article about Witt said, "He is always willing to do what he can to make someone else comfortable or pleased." (Courtesy of the Workman family.)

The wedding ceremony on July 12, 1924, symbolized the union of Graham, Virginia, and Bluefield, West Virginia, and the Graham name change to match the sister city. The bride and groom were Wingo Yost of Virginia and Emma Smith of West Virginia. The minister was the Reverend W. E. Abrams. On the right of the groom is the governor of West Virginia, E. E. Morgan. Virginia governor E. Lee Trinkle is on the left of the bride. This unique ceremony was publicized throughout the nation. The name of Graham was changed to Bluefield, but the old name is still used in many places and by many people. The first mayor of Graham was W. T. Linkous, elected in 1884. (Courtesy of Graham Historical Society.)

A huge crowd attended the ribbon-cutting ceremony in 1924 in which the name change from Graham to Bluefield was officially proclaimed. Up to that time, this occasion attracted the largest crowd ever assembled in the old Graham and new Bluefield, Virginia. (Courtesy of Craft Memorial Library and Eastern Regional Coal Archives, Bluefield, West Virginia.)

West Virginia governor E. E. Morgan (right) and Virginia governor E. Lee Trinkle officiated at the "marriage" of the two Bluefields in July 1924. On that day, a name change took place in Bluefield, Virginia, for the fourth time, from Pin Hook to Harman to Graham to Bluefield. The merger was especially exciting when Emma Smith of West Virginia and Wingo Yost of Virginia were pronounced man and wife by the minister, W. E. Abrams. (Courtesy of Graham Historical Society and Craft Memorial Library and Eastern Regional Coal Archives, Bluefield, West Virginia.)

This modern chamber of commerce exhibit of the Graham Mattress Company follows a long established tradition of quality from 1889 to the present. It is recorded that the company specialized in upholstering and repairing in 1914. The mattress company was established by a pioneer settler, O. A. Metcalfe. (Courtesy of Craft Memorial Library and Eastern Regional Coal Archives, Bluefield, West Virginia.)

The interior of the Aratex Rental Company shows some of the employees and equipment of this important Bluefield business. Aratex is an example of one of the more modern industries to have located in Bluefield, Virginia. (Courtesy of Craft Memorial Library and Eastern Regional Coal Archives, Bluefield, West Virginia.)

Westgate Shopping Center was one of the first shopping centers in Bluefield. The anchor stores were the A-Mart and the Virginia Acme Market. (Courtesy of Craft Memorial Library and Eastern Regional Coal Archives, Bluefield, West Virginia.)

Pemco, a large employer among the Bluefield industries, has helped keep Tazewell County's economy on a sound basis. Pemco is noted for the manufacture of mining equipment and other industrial products. (Courtesy of Karen Woody, Marcia Muncey, and Graham Middle School.)

The Keebler plant is one of the modern industries that have added to the expanding business climate Bluefield has experienced. Keebler produces a variety of food products. (Courtesy of Karen Woody, Marcia Muncey, and Graham Middle School.)

Joy Manufacturing adds to the area's emphasis on the coal industry with its manufacture of mining equipment. Early Graham depended on the expanding coalfields, and the importance of the coal economy continues into modern times. (Courtesy of Karen Woody, Marcia Muncey, and Graham Middle School.)

The Double Gates Grocery is a mainstay for the Bluefield people who enjoy good food and the convenience of hometown shopping. One of the local favorites prepared here is the famous "Double Gates Hot Dog" with its homemade chili. This building is close to the site of the early toll road at the famous "double gates" on the early farm lands. (Courtesy of Mullins files.)

The James F. Dudley store on Virginia Avenue in about 1919 was near the Thistle Foundry and the West Graham Post Office and across the tracks from the Seyler Lumber Company. It was at the end of the Graham/Bluefield (West Virginia) streetcar line. James Glen Dudley was the proprietor. The man and children in the picture are unidentified. (Courtesy of the Dudley family.)

Donald Harris, Bluefield mayor in 2009, holds the 1964 contest rules for the town slogan. The competition was won by Bill Osborne, whose winning slogan was "Virginia's Tallest Town." The competition was sponsored by the Community Improvement Association, and the winner received a $25 savings bond. Among other slogans submitted was one written by Helen McNeer, which Bill Osborne said he "liked the best." Her entry was "Gateway to Southern Hospitality." (Courtesy of Don Harris.)

Bluefield Town Council members in 2009 are, from left to right, Ed Shaffrey, Donnie Linkous, Anglis Trigg Jr., Jimmy Jones, Rick Taylor (vice mayor), Donald Harris (mayor), and Todd Day (town manager). (Courtesy of the Town of Bluefield, Virginia.)

Four
FAITH AND LEARNING

The modern Bluefield Town Hall in the Double Gates area rivals any town government building in Virginia for beauty and facilities. Much of the town's recent development has centered on Double Gates, reminiscent of the early days when farm traffic made the area a busy place. Double Gates is mentioned in historic records as the site of a toll road between the Tazewell Court House and Graham Turnpike. An 1889 receipt for the toll lists John Hambrick as the gatekeeper. (Courtesy of Mullins files.)

Wartburg Seminary and later Graham College were recognized educational institutions that stood on the "hill of learning," which has been the site of a school for over 125 years. After the closing of the college, the old Graham High School and the Graham Intermediate School occupied the site. J. B. McClure headed the college staff. Along with academic excellence, the college is remembered for its famous 1906 baseball team coached by the Reverend Sam W. Moore. In 1893, Dr. J. B. Greever, principal, had as his assistant J. T. Crabtree, and the enrollment peaked at 114 students. The seminary closed in 1896, but the Lutherans kept the name when the Wartburg Lutheran Church was established in 1901. (Courtesy of the Lutheran Church in Virginia archives and Margaret Elam.)

The boys' dormitory at Wartburg Seminary was a great gathering place for students and their families. In this picture, there seem to be many guests at the large building, affectionately known by the students as "The Ark." (Courtesy of John Spracher.)

The Graham College baseball team names have been lost except for the two men in the doorway. Seated at right is Robert Baylor. Standing next to Baylor is Sidney Saunders, who is presumed to be the coach. (Courtesy of Craft Memorial Library and Eastern Regional Coal Archives, Bluefield, West Virginia.)

The old Graham High School building was constructed in 1914. It served as the town's beloved high school until the present building was completed in 1957. The Graham Intermediate School now stands on the old site. In fact, the gymnasium for the old Graham High School is part of the intermediate school facility to this day. The very first schools in Bluefield, Virginia, were two-room structures on Keister Street and at St. Clair's Crossing. There is a special loyalty to the Graham/Bluefield, Virginia, schools that gives them an importance in the community, yesterday and today. (Courtesy of Margaret Elam and Lisa's Barber Shop.)

A disastrous fire with damage estimated at half a million dollars destroyed the old Graham High School on New Year's Eve in 1957. The cause of the fire was never determined, but it spread quickly through the structure after being seen by a neighbor at about 6:30 p.m. Principal M. L. Louthan crawled through a window into the office and saved most of the vital records. (Courtesy of Anthony Stephens and Joann Harman.)

This group of eager students attended the Falls Mills School in the early 1930s. All of them cannot be identified, but their family names include Akers, Buckland, Banner, Britten, Bales, Caldwell, Compton, Cumby, Dainley, Deaton, Ernest, Flowers, Fowlers, Gillespie, Harrell, Hunnell, Harold, Haiel, Hill, Hall, Harris, Hughes, Hedrick, King, Powell, Phillip, Perdue, Pershea, Reynolds, Scott, Spracher, Sturgess, Sarver, Thomas, Tabor, Tickle, Wimmer, Walk, and Wilson. (Courtesy of Lisa's Barber Shop.)

84

The St. Clair's Crossing school is the oldest standing school building in Bluefield, Virginia. It was built in the early 1900s and closed in 1940. It was named for the prominent St. Clair family and the nearby railroad crossing. (Courtesy of Anthony Stephens.)

The 1932 students at the St. Clair's Crossing school, with their teacher Juanita Fleshman, included (not in order) Josie Herald, Virginia Lawson, Ruth Brooks (Lampert), Gladys Brooks Crawford, Jean Smith Graham, Zona Robinson, Jean Thompson, Zelma Fleshman, Jeff Herald, Will Tom Brooks, Hazel Burress, Emm Hughes, Nettie Hughes, Beatrice Burress, Gladys Burress, Ruby McFarland, Dennis Fleshman, Jack Yost, Sam Herald, Ann Patrick, James Burress, Thelma Gilmore, Willard Patrick, and others. The St. Clair's Crossing school, built in the early 1900s on land close to the St. Clair family home, closed in 1940. (Courtesy of Ruth Brooks Lampert.)

The location of the Logan Street school has been used by different educational institutions in its long history. It was built in 1922 and closed as a public school in 1980. According to Irma Nunn Webb, Bluefield historian and one of the principals at the Logan Street school, "The school was administered by head teachers and principals of Graham High School until Graham Intermediate School was established in 1959." Among the acting principals were M. R. Louthan, Edward Fortune, Frances Yost, and Bill Dove. Irma Webb served as principal of Logan and Dudley schools in 1975. The renowned Hotel Graham stood on this high hill in the late 1880s. It was managed by a Frenchman who brought his entire staff with him from Vermont. The Logan Street site is now home to the National Business College. (Courtesy of Graham Historical Society and Margaret Elam.)

Evelyn Russ Hardy (standing in the back) was the teacher for this large elementary school class in 1949. This was at the Logan Street school, and perhaps, at that time, there was more than one grade in the same classroom. (Courtesy of Donald Harris.)

The setting for this photograph of the 1945 Graham High School cheerleaders is almost as pretty as the enthusiastic girls. They are, from left to right, Billie Osborne, Jackie Morgan, Muriel McClintock, Joyce Morgan, Joyce Leffel, and Phyllis Anderson. (Courtesy of Debra Waugh and Graham High School.)

The *Graham Cracker* was the unique name of the annual at Graham High School in 1940–1941. A much earlier annual in 1916 was called *The Shawn*. By 1942, the annual had its present name, *The Graham*. This 1940 edition of the *Graham Cracker* seemed to be a special year for the students who wrote this foreword to introduce their new annual: "Nestled near East River's ridges / With its lines of blue / Stands our noble Alma Mater / Glorious to view. / G-Men faithful / G-Girls grateful / Conquer and prevail. / Graham High all hail." This foreword now serves as the lyrics of the Graham High School Alma Mater. The cornerstone was laid for this high school in 1913. The cornerstone for the new high school at Double Gates was laid in 1955. (Courtesy of Debra Waugh and Graham High School.)

THE
GRAHAM
CRACKER
1940

The Graham High School cheerleaders in 1958 had pretty outfits, which added to the sports picture. They are, from left to right, Phyllis Leedy, Judy Peters, Bonnie Burkett, Patty Doak, Ann Bourne, Adean Perdue, Ann Smith, and Dana Burkett. (Courtesy of Debra Waugh and Graham High School.)

The 1942–1943 Graham High School varsity club was coached by John Anderson (standing left). The club members, "letter men all," are, from left to right, (first row) Pat Denardo, Luther Barrett, Jackie Wysor, Earl Shaw, and Jack Harmon; (second row) John Hodnett, Joe Oblinger, John Oblinger, and Wallace Kerley; (third row) coach John Anderson, Freeman Turley, Zane Barrett, Jimmy Bates, Leon Gill, Herbert Longworth, Eugene White, Harold Mathena, Jack Richardson, Gordon Barrett, Ernest Honaker, and Bobby Smith. (Courtesy of Debra Waugh and Graham High School.)

The Tazewell County High School was built in 1925. This structure formerly served the African American students from throughout Tazewell County. Principals of note were W. N. Green, J. A. Hubbard, and W. H. Brothers, among others. The building became Graham Junior High and was used until 1981, when it was closed at the opening of the new Graham Middle School. (Courtesy of Eva Saunders.)

The original Tazewell County High School was later converted into an apartment complex known as the Graham Manor. The building was sketched here by the Reverend Dr. Don Scott. (Courtesy of the Reverend Dr. Don Scott.)

These Falls Mills students in 1908 dressed for the photographer on a proud day at their school. They cannot be identified by Lillian L. B. Holt, who contributed the picture, except for her late mother-in-law, Mary Rohrer (or Roarer). She is the eight-year-old child in the first row with the blond hair and serious expression. (Courtesy of Lillian Lovelace Brooks Holt.)

Graham High School, pictured in 1959, continues to be recognized for its excellence in scholastic and athletic achievements. The athletic field, the proud home of the G-Men, is at left. In 1989, Irma Webb, retired teacher and historian, listed the existing Bluefield public schools: Dudley Primary, Graham Intermediate, Graham Middle School, and Graham High School. Another well-known educator, among many through the years, is Virginia Garwood, who served as director of instruction for Tazewell County schools. The first principal at the new Graham High School was Lewis Dalton, who served until 1963. (Courtesy of Craft Memorial Library and Eastern Regional Coal Archives, Bluefield, West Virginia.)

These leading citizens from the two Bluefields met with the Virginia Baptist Association in August 1919 to urge the association to locate Bluefield College in the area. Their success resulted in the excellent four-year coeducational institution that stands today close to the state line in Virginia. There are 49 men known to have attended the initial meeting in Bristol. (Courtesy of Craft Memorial Library and Eastern Regional Coal Archives, Bluefield, West Virginia.)

Bluefield College opened its doors to students in 1923. At that time, there was only one central building on the campus. The first president was Dr. R. A. Lansdell. Other presidents include Dr. J. Taylor Stinson, Dr. Oscar E. Sams, Dr. Edwin C. Wade, Dr. Charles L. Harman, Dr. Charles Tyer, Dr. Gary M. Garner, Dr. Roy A. Dobyns, Dr. T. Keith Edwards, Dr. Daniel G. MacMillan, Dr. Charles Warren, and the present head of the college, Dr. David W. Olive, who arrived in 2007. (Courtesy of Craft Memorial Library and Eastern Regional Coal Archives, Bluefield, West Virginia.)

One of the most beautiful and most used buildings on the Bluefield College campus is Harman Chapel, pictured under construction. It is named for a beloved past president, Charles Harman, who served from 1946 to 1971. (Courtesy of Craft Memorial Library and Eastern Regional Coal Archives, Bluefield, West Virginia.)

This view of Bluefield College a few years after it opened shows three buildings on the wide campus, which has now been filled with new buildings as the college has grown. There has also been a big growth in housing near the campus. Bluefield College holds the singular honor of being the only private college in Virginia to reduce tuition. In 1997, it was reduced by 23 percent. (Courtesy of Lisa's Barber Shop.)

The campus of Bluefield College, which stands close to the Virginia/West Virginia border, has grown since the 1919 planning stage into a highly recognized four-year coeducational institution of higher learning. City Park can be seen at the top of the picture. In recent years, the Christmas lights display at the park has become a popular attraction. (Courtesy of Craft Memorial Library and Eastern Regional Coal Archives, Bluefield, West Virginia.)

Wartburg Lutheran Church is pictured on Virginia Avenue in the 1920s. In 1888, Dr. Joseph B. Greever founded the Wartburg Evangelical Lutheran Church. The cornerstone for the new frame building was laid in 1904. Prior to worshipping at the Wartburg Church, the Lutherans attended the Immanuel Lutheran Church, the oldest church in Bluefield, West Virginia, according to information written by Glen Tate Dudley. (Courtesy of the Dudley family.)

Dudley Memorial Mortuary in 1953 incorporated the Wartburg Evangelical Lutheran Church into its building to form a funeral home, which can claim to be "the only funeral home in the nation with an authentic church chapel." (Courtesy of Craft Memorial Library and Eastern Regional Coal Archives, Bluefield, West Virginia.)

The Graham Christian Church was organized in 1891, and the first minister (possibly the insert) was J. R. McWane. The congregation now worships in a new building that dates from 1921. The motto for the active church remains "The friendly church on the corner." (Courtesy of Lisa's Barber Shop.)

The Graham Christian Church, a beautiful stone structure, replaced the original church, which burned on Thanksgiving Day in 1953. The Disciples of Christ congregation has deep roots in this part of Virginia. (Courtesy of Robert Perry.)

A Sunday school group from the Graham Christian Church met on the porch of the Dudley home in 1912 (date presumed from the Woodrow Wilson poster in the window). Two of the host family are identified. They are Charles Hugh Dudley in the white shirt, leaning against the post, and, seated on the far right, James Glenn Dudley. (Courtesy of the Dudley family.)

The Virginia Avenue United Methodist Church has roots dating back to 1914, when work was started on the building of the West Graham Methodist Episcopal Church South. C. E. Painter preached the first sermon in 1916 at the church located at the corner of Lowe Street and Greever Avenue. A parsonage was built in 1924 on Greever Avenue. As early as 1936, plans were made for a new and larger building. A lot was donated by E. D. Creasy, and work started on the beautiful new building in 1949. The building was completed in 1951 and dedicated in 1958 under the ministry of the Reverend Bernie H. Hampton. Among the many faithful members through the years have been Eva Pope and Ruth Fleshman, who were choir members for over 50 years. (Courtesy of Joyce Buchanan.)

Three members of the Virginia Avenue United Methodist Church have entered the pastoral ministry of the United Methodist Church. They are, from left to right, the Reverend Dr. Don Scott, the Reverend Mary K. Pope Briggs, and the Reverend David Warden. (Courtesy of the Reverend Dr. Don Scott.)

Don Scott was ordained an elder in the United Methodist Church at the Virginia Avenue United Methodist Church on October 22, 1967. Pictured with him are, from left to right, the Reverend French Taylor, pastor of the church; the Reverend Sam Bratton, superintendent of the Tazewell district; the Reverend Jim Hankins of Pearisburg; and the presiding bishop of the Holston Conference, Bishop H. Ellis Finger Jr. (Courtesy of the Reverend Dr. Don Scott.)

Bluefield's Memorial Baptist Church, among the many active churches in the town, holds a special place in the community. The building dates from 1900. In 1889, E. T. Mason came to Graham to organize the Baptist congregation. At first, the members met in an old store house on Mason Street. After many years, the old building was lost in a fire. The current beautiful place of worship was soon built, and the first service was held in the new facility on Easter Sunday morning in 1966. (Courtesy of Stephanie Rose Musick and Joe Newton.)

The men's Bible class at the Memorial Baptist Church on Virginia Avenue represents many Bluefield leaders. Although the members are unidentified, their impact on the community and their dedication to the church at mid-20th century is obvious. (Courtesy of Lisa's Barber Shop.)

The First United Methodist Church is one of Bluefield's impressive buildings with a rich history of service to the community. In this sketch by the Reverend Dr. Don Scott, some of the Tiffany stained-glass windows can be seen. (Courtesy of the Reverend Dr. Don Scott.)

James L. Douthat (center) of Bluefield, Virginia, was ordained as a Methodist minister in 1965 by these church leaders. From left to right are (first row) the Reverend Marvin S. Kincheloe and the Reverend A. N. Williams; (second row) Bishop Ellis Finger and the Reverend Al Brewster. Reverend Douthat is now serving in Chattanooga, Tennessee. He is the son of Robert and Mary Douthat. (Courtesy of Margaret Elam.)

The choir of the First United Methodist Church in Bluefield included 16 members at a service in 1948. The members were, from left to right, (first row) Clara Omar, Barbara Morgan Bates, Irene Gill, Nell Doak, ? Wagner, Helen McNeer, Sue Lambert, and ? Davis; (second row) ? Williams, Charles Maxie, Ben Bates, ? Barnett, George Reynolds, two unidentified, and H. Wagner. Organist was Irene Bates. (Courtesy of Dr. James B. McNeer.)

The beautiful Tiffany stained-glass windows at the First United Methodist Church are a great addition and much appreciated in the community. The memorial windows were placed in the church in 1922 when the building was erected. The eight windows were placed by the Crockett, Bane, Hicks, Brown, Pile, and Bailey families. (Courtesy of Lori Moss.)

St. Mary's Episcopal Church on Tazewell Avenue was built in 1910 by Italian stonemasons who worked for the Norfolk and Western Railroad. The building and the rectory behind it were built of huge sandstone blocks quarried at Falls Mills. The land was donated by Hudson Huffard. Ernest Rich was the rector when the buildings were constructed. (Courtesy of Mullins files.)

The Reverend Russell Hatfield stands behind the historic Robert E. Lee pulpit, which was given to St. Mary's Episcopal Church in 1910. It was a gift from the Robert E. Lee Memorial Episcopal Church in Lexington. General Lee preached from this pulpit when he served as senior warden in the Lexington church. The Bluefield St. Mary's Church was formed in 1895, and the present building at the corner of Tazewell and Logan Streets was built in 1910. The beautiful altar window was given in memory of Robert and Thomas Williamson. (Courtesy of Mullins files.)

The congregation of the Bethel United Methodist Church assembled at the last worship service in the old building, erected in 1905 under the pastorate of the Reverend William Pleasants. The trustees of this 1905 church were A. B. Ward, C. D. Shell, Charles Green, James A. White, Charley Trigg, and John Holley. The new building, completed in 1977, was started under the pastorate of the Reverend A. R. Fleshman. (Courtesy of Graham Historical Society.)

Pastor Caleb Lilly (front center) and church members assembled in front of a partial view of the new Bethel United Methodist Church, built in 1977. Among the hundreds of faithful members who have served the old and new churches was J. S. Painter, church school superintendent for over 50 years. (Courtesy of Graham Historical Society.)

James E. Rogers was recognized by the Town of Bluefield for his many years of service on the board of the Planning Commission. In 1998, the mayor of Bluefield, John L. Hurley, presented him a certificate of resolution in appreciation for his service. (Courtesy of Eva Saunders.)

The Reverend James A. Palmer was the pastor of three different Baptist churches in the two Virginias, including the Tabernacle Baptist Church in Bluefield. He served the Bluefield church for 35 years. The other churches were in Landgraff and Algoma. The Bluefield church was started in 1885. (Courtesy of Eva Saunders.)

The senior choir members of the Tabernacle Baptist Church from 1940 to 1950 included, from left to right, (first row) Catherine Walton, Dora Henry, Blanche Watkins, Hattie Anderson, Amy Williamson, and Amy Hopkins; (second row) Isadore Harris, Lacy Robertson, Sarah Robertson, Gladys Watkins, George Hopkins, and Charles Williamson. (Courtesy of Eva Saunders.)

West Graham in 1924 was photographed by W. C. Breckenridge when the funeral procession for James F. Dudley made its way into the Maple Hill cemetery grounds. The highly regarded James Dudley, Bluefield businessman and civic leader, made a great impact on the community. His friends at the burial service filled the Maple Hill grounds and Virginia Avenue. The first burial at Maple Hill Cemetery was in the mid-1800s. Even here in the 1920s, much of West Graham was yet to be developed. (Courtesy of Margaret Elam and the Dudley family.)

Five

Blue Fields of Dreams

The national sports writers called him "Bullet Bill." It all started at Graham High School in 1938 when Bill Dudley kicked a 35-yard field goal in the season's finale and helped beat Princeton High School 10-7. At age 16, he was awarded a football scholarship at the University of Virginia. In his senior year at UVA, he became the school's first player to win All-American honors. After college, he became an outstanding running back and place-kicker for the National Football League. He starred three years each for the Pittsburgh Steelers, the Detroit Lions, and the Washington Redskins. His 1941 record at the University of Virginia when he ran or passed for 29 touchdowns still stands in the history books. Overall in 1941, Bill Dudley topped the national college records with 134 points and total yards gained. Dudley now lives in Lynchburg, where he went into the insurance business with his brother, Jim Dudley. (Courtesy of the Dudley family.)

The town of Bluefield looked big from the air in 1924. In July of that year, the name change from Graham to Bluefield took place. The photographer aimed his lens toward West Virginia, perhaps as a symbolic gesture. The "Graham" name is still used in many places as a reminder of days gone by. (Courtesy of Venture Printing and Office Supply and David Moore.)

An aerial view of City Park makes it appear to be in a deep forested setting. This was the original site of Bluefield's air strip and later Mitchell Stadium and the Bluefield Auditorium. The top portion of the park is in Virginia, but the entire park area belongs to the City of Bluefield, West Virginia. It is used by both communities. (Courtesy of Craft Memorial Library and Regional Eastern Coal Archives, Bluefield, West Virginia.)

Bowen Field is recognized as outstanding among sports facilities in the two Bluefields. The sports picture is important on both sides of the state line, and in the early 1930s, the Bluefield Athletics and the Graham Red Sox joined to form the Blue-Grays united team. The new name combined the "blue" of each town and also recognized a Confederate and a Union state, the blue and the gray. (Courtesy of Craft Memorial Library and Eastern Regional Coal Archives, Bluefield, West Virginia.)

This aerial view of the Bluefields includes (top left) downtown Bluefield, Virginia, the Bluefield City Park complex in the center, and (bottom left) the Bluefield College campus. Bowen Field, center left, is now home to the minor league professional baseball farm team, the Bluefield Orioles. The franchise celebrated its 50th year of existence in Bluefield in 2008. This remains the longest continuous relationship of any minor league team to a parent organization in professional baseball. The Orioles play in the Appalachian Baseball League. (Courtesy of Grubb Photo.)

The popular Fincastle Country Club was under construction in this 1962 view from the air. Fincastle Country Club receives a high rating from golfers nationwide as well as locally. The setting in the shadow of East River Mountain is ideal for golfers on a warm spring day. (Courtesy of Craft Memorial Library and Eastern Regional Coal Archives, Bluefield, West Virginia.)

In the 1920–1921 season, the Graham High School girls' basketball team was named Virginia State Champions. Team members were, from left to right, (first row) Helen Baylor McNeer and Margaret McCall; (second row) Nell Whitesell Greiser, Mamie Sexton, and Catherine Strickland French; (third row) coach Grace Kruikshank, Catherine James Newton, Edith Pyle Hinton, Virginia Peery Tilson, and school principal ? Meredith. In 1906, another early athletic achievement gained widespread publicity. It was the famous baseball team of Graham College coached by the Reverend Sam W. Moore, pastor of the Graham Presbyterian Church. Team members were Reese Anderson, Amos Wade, Frank Baylor, Beverly Litz, Jesse Franklin, Albert Litz, Arthur Preece, Harry Waters, Walter Keister, and Ted Williams. (Courtesy of Margaret Elam.)

McLain's Business College, a former school in Bluefield, Virginia, known for its excellence, added to the sports picture with a championship softball team in 1947. Team members were Harold Hawks, Walter Wilson, Thomas Matson, James Kensinger, Frank Allen, David Earnest, Kenneth Kensinger, Charles Butler, Ratliff Johnson, Ramond Walaczka, Harrell Altizer, and Ralph Cordle. (Courtesy of Margaret Elam and Louise McKinney.)

The 1955–1956 Virginia State Basketball Championship went to the proud G-Men at Graham High School. The team compiled a remarkable record of 23 wins and only 3 losses. This was the only GHS basketball team to win the state title. (Courtesy of the Dudley family.)

The football coaching staff in the mid-1960s at Graham High School included, from left to right, Lawrence H. "Burrhead" Bradley (head coach), Bob Hedrick, Ed Brooks, and Sam Crockett. (Courtesy of the Dudley family.)

Coach Lawrence H. "Burrhead" Bradley (seated) congratulates Dickie Asbury, Graham High School student, when he won All-American honors for his high school football career. (Courtesy of the Dudley family.)

The Graham High School G-Men proudly pose for their honor photograph in 1962. They were the first Graham team to earn the title of Virginia State Football Champions. They defeated cross-county rival, the Tazewell Bulldogs, that year 7-6 as a significant part of their undefeated season. (Courtesy of Tammy Williams and Rusty Fife.)

These 1962 state champions in football at Graham High School continued their sports careers in college. From left to right are Don Danko, who played at the University of Kentucky; Rusty Fife at Virginia Tech; coach Lawrence H. "Burrhead" Bradley; and Hunce Bourne, the first white player at Bluefield State College. (Courtesy of the Dudley family.)

The Graham High School G-men defeated Southampton High School to earn the Virginia State Championship title in 1989. The coach was Glynn Carlock. From left to right are (first row) Beth Dudley and Glynn Carlock Jr.; (second row) Brian Hoops, Tony Young, Chris Patton, Eddie Caldwell, Tony Palmer, Mike Patton, Erik Robinson, and Lance Barbour; (third row) Eric Workman, Ryan King, Chris Stacy, David Lawson, Marcus Latimer, Roland Pascasio, Rick Brown, and J. J. Caffrey; (fourth row) Terry Quesenberry, Jeremy Carbaugh, Todd Massey, Chris Austin, Brian Denham, Graham Thompson, Scott Grimm, and Bill Dudley; (fifth row) Ronnie Raley, Brian Johnston, Doug Grose, Jeff Johnson, Josh Hornbarger, Brent Surface, Chris Cox, Todd King, and Randy Belcher; (sixth row) Josh Compton, Andy Russell, Todd Bovenizer, Ben Millsap, Robert McFarland, Steve Bunker, Charlie Stiltner, and Kapes Workman; (seventh row) Nicky Maupin, John Pruett, Randy Russell, Mark West, Rodney Bailey, Scott Alderman, Shane Yost, Robert Helmandollar, and Chris Holleyfield. Not pictured is John Grubb. (Courtesy of Doug Marrs and Tammy Williams.)

The Graham High School football team won the Virginia State Championship again in 1995 when they defeated King George County High School. The coach was the popular Glynn Carlock. (Courtesy of John Patrick O'Neal and Graham High School.)

Ahmad Bradshaw, a 2004 Graham High School graduate, was the leading rusher for the New York Giants during the XLII Super Bowl victory in 2008. Among other football records, he played a key role in the 17-14 victory over the New England Patriots in February 2008. (Courtesy of Debra Waugh and Graham High School.)

Glynn Carlock, legendary football coach at Graham High School, served as coach and mentor for 32 years. At different times, he held the jobs of athletic director and coach of baseball, soccer, wrestling, basketball, and track. Carlock posted 254 wins, 2 state titles, and a .671 winning percentage as football coach. His philosophy was "there's only one way, and that's the right way." (Courtesy of Doug Marrs and Graham High School.)

The Graham High School girls' tennis team won the Virginia State Championship title in 1999. From left to right are (seated) Deanna Coon, Cecilia Presley, Lauren Williams, Ellie Simpson, and Susan Eggleston; (standing) Zubia Ahmad, Alexa Jones, Megan Cornwell, Cindy Chaffins, Lina Qazi, and coach Tamara Williams. (Courtesy of Joann Harman and Gail Harman Williams.)

The Graham and Beaver football teams met in 1930 at Mitchell Field. The striped maroon and gray uniforms designate the Graham team. This is believed to have been the year Mitchell Stadium opened. (Courtesy of the Dudley family.)

The Bluefield, Virginia, Barons were named the minor league football national champions in 2006. This semiprofessional team's members were from a wide area, but the Bluefield players were (not in order) David Bailey, Jon Jessup, Cliff Bradshaw, Leonard ("Sugar Ray") Graves, and Glen Keene. Head coach was Bill Dudley, and the general manager was Shane Yost. Dudley (first row, center) was named national coach of the year in 2005 and 2006. (Courtesy of the Dudley family.)

The year 1963 was a banner year for football for both Graham High School and Bluefield High School in West Virginia. Both schools earned state championship titles. The two coaches met for this historic picture. On the left is Merrill Gainer of West Virginia, and at right is Lawrence H. "Burrhead" Bradley of Graham. Bradley, unhappy with a small Virginia trophy, purchased a new version of the Virginia State Trophy for this famous photograph. (Courtesy of Craft Memorial Library and Eastern Regional Coal Archives, Bluefield, West Virginia.)

The Graham High School band was pictured in the 1940 annual, and these members were listed: A. B. Shufflebarger, Wanda Smith, Eugene Hager, Wallace Kerley, Jimmy Wells, Jimmy Blankenship, Joseph Horn, Everett Thompson, Charles Weeks, Steve Jackson, Gordon Barrett, Arlene Goosby, and director T. M. Gillespie. The members on the third row are, from left to right, Leon Gills, Roy Steele, Jack Summers, Harry Burton, Mary Alice Hodnett, Dora Wilson, Bill Longworth, Amelia Bullio, Jimmy Bates, Bill Pruett, Earl Shaw, and Edna Longworth. (Courtesy of Debra Waugh and Graham High School.)

The Richwood Golf Club and Campground is a relatively new business established by the Rich family. Its beautiful setting is recognized by all visitors. (Courtesy of Karen Woody, Marcia Muncey, and Graham Middle School.)

The Fincastle Country Club not only provides recreational opportunities for the people of Bluefield but also heralded the building of several fine homes at the base of East River Mountain, known as the Sedgewood neighborhood. The course was designed by noted golf course architect Dick Wilson and opened for play in 1963. (Courtesy of Karen Woody, Marcia Muncey, and Graham Middle School.)

These swimmers in the 1920s cannot be identified, but the location of the picnic and swimming party was the McMullin Dam near Hockman Pike. The enjoyment of the day is evident in the many happy faces. (Courtesy of Ellen C. Miller.)

Harmony Acres swimming pool was opened in 1953 under the management of Oaka Williams, a well-known Bluefield athlete who designed and built the pool. It was a $50,000 project, and the pool holds 350,000 gallons of water. Its depth is graduated from 2.5 to 10 feet. The B. W. Harman home place, on the left back, stands close to the pool on Crescent Street. (Courtesy of Joann Harman and Gail Harman Williams.)

Oaka H. ("Oakey") Williams built the Harmony Acres swimming pool, which has created much pleasure for Bluefield children and adults. The pool was opened in the mid-1950s close to the Blaine W. Harman home. Williams married Gail Harman, and the Harman family maintained an interest in the project. Williams died at age 77 in 2008 after putting the finishing touches on the pool in anticipation of the season's opening. A friend, Terry Kirk, said, "Oakey gave his heart and soul to the young kids of this community." (Courtesy of Joann Harman and Gail Harman Williams.)

When Harmony Acres, the popular recreation center, attracted its summer crowd on the sandy beach by the pool, Oaka Williams became a sand sculptor. He imported the sand from Virginia Beach to create an authentic beach. (Courtesy of Joann Harman and Gail Harman Williams.)

Shannondale was a popular recreational site in the 1920s and 1930s. It has continued through the years as a place for swimming and camping and now has developed into the new Camp Joy, which lives up to its name. In the early picture, the vintage cars line the roadway and it seems East River Mountain is watching over the scene, then as now. (Courtesy of Ellen C. Miller.)

The falls on the Bluestone River were the site of an early mill, and the area became well known for its natural beauty and a railroad stop. Originally, before the dam was built, there was a combination gristmill, flour mill, and sawmill on the waters of the Bluestone. The dam was built in 1908 by Samuel Walton with stone from his Brush Fork quarry. (Courtesy of Venture Printing and Office Supply and David Moore.)

The Falls Mills recreational area is focused around the natural falls and the dam that were constructed in the early 20th century. The lake is a favored spot for both swimmers and fishermen. (Courtesy of Lisa's Barber Shop.)

A baptismal service in the waters of the Falls Mills dam attracted a large crowd in 1921. Using rivers and streams to baptize was common practice before most churches built baptismal pools inside the buildings. (Courtesy of the Dudley family.)

Evans Omar may be waiting for a passenger to ride in his shiny Studebaker. His daughter is Nancy Trenton, well-known Bluefield resident and longtime Tazewell County teacher. Old-timers may remember the rumble seat, a necessity in many early cars. (Courtesy of Nancy Trenton.)

The Graham Town Band, pictured in the early 1920s, marched from West Virginia into their Virginia hometown for a special parade. All the band members cannot be identified, but it is recorded that the following men and boys were part of the group: Allen McMullin, Bob Mahood, Lawrence Edwards, "Wild Man" Lawson, Roy Portis, E. Roy Yost, Willis Anderson, Emory Summers, Earl Mahood, Dick Ramage, Gene Mahood, and Tom Shawver. Two of the bystanders on the right were identified as Tony Vengen and Frank Denardo Sr. (Courtesy of Ellen C. Miller.)

The August 28, 1964, flooding of Bluefield was one of the worst floods of many remembered in the town. Property and buildings were heavily damaged in downtown west toward West Graham. (Courtesy of Craft Memorial Library and Eastern Regional Coal Archives, Bluefield, West Virginia.)

Looking west from the state line, the viewer can see the railroad junction with the route to the right leading to Pocahontas and West Virginia coalfields and to the left to Tazewell and the Clinch Valley coalfields. Downtown Bluefield, Virginia, is at the center of the photograph. (Courtesy of Grubb Photo.)

The Town of Bluefield participated in the statewide commemoration of the 400th anniversary of the Jamestown settlement in 1907. They buried a time capsule, containing pertinent local information, on the grounds of the town hall in the year 2007. It will be opened in 2032. Members of the Graham Historical Society, town officials, and others from the community took part in the celebration. The people holding the shovels are, from left to right, Lynn Burnette, Don Scott, Joyce Johnston, Linda Trigg, Annie Ruth Anderson, Norma Hedrick, Eva Saunders, Robert Perry, Betty Corte, Margaret Ratcliff, Barbara Bates, and Viola Asbury. (Courtesy of the Town of Bluefield, Virginia.)

The Sanders House Center is directed by a board of managers, appointed by the Graham Historical Society, which owns the property. Members of the board are, from left to right, (first row) J. C. Higginbotham, Eugenia Hancock, Dolores Pritchett, Jackie Oblinger, and Fred Adams; (second row) Robert Perry, June Brown, Jack Brewster, Betty Corte, Barbara Bates, and Don Scott, chairperson. (Courtesy of the Reverend Dr. Don Scott.)

125

From the air, Bluefield seems especially close to East River Mountain. Across the mountain and in the distance, it is possible to see Clear Fork Valley, Rich Mountain, and the eastern half of Burkes Garden in Tazewell County. Round Mountain, Brushy Mountain, and Big Walker Mountain are visible in nearby Bland County. In the distance across the great valley stand the Blue Ridge Mountains of Virginia. (Courtesy of Grubb Photo.)

This well-known aerial photograph, entitled "Fog Over East River Mountain," was taken in December 1993 by Mel Grubb and records a unique weather phenomenon. The graceful vapor combined with the natural beauty and lay of the land to create a grandiose effect. Grubb remembers, "The fog extended for 60 or 70 miles and continued to shroud the mountain well into the night." The fog here rolls from Bland County into the Bluestone Valley and the blue fields of home. (Courtesy of Grubb Photo.)

ER THOUSANDS OF LOCAL HISTORY BOOKS
TURING MILLIONS OF VINTAGE IMAGES

...ia Publishing, the leading local history publisher in the United States, is committed to making history accessible and meaningful through publishing books that celebrate and preserve the heritage of America's people and places.

Find more books like this at
www.arcadiapublishing.com

Search for your hometown history, your old stomping grounds, and even your favorite sports team.

Consistent with our mission to preserve history on a local level, this book was printed in South Carolina on American-made paper and manufactured entirely in the United States. Products carrying the accredited Forest Stewardship Council (FSC) label are printed on 100 percent FSC-certified paper.

MADE IN THE USA